# ALFREDA'S WORLD

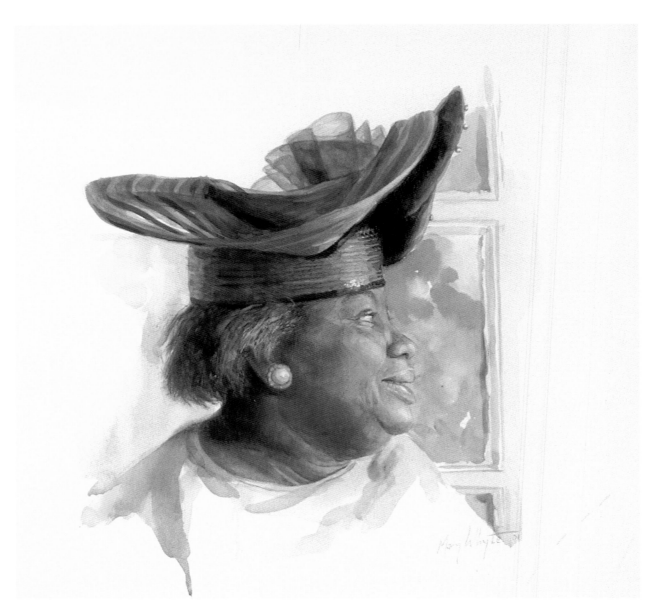

*Alfreda*

# ALFREDA'S WORLD

Mary Whyte

Wyrick & Company
*Charleston*

Published by Wyrick & Company
Post Office Box 89
Charleston, SC 29402

Designed by Sally Heineman
Printed by C&C Offset Printing Co., LTD

Library of Congress Cataloging-in-Publication Data

*For Alfreda, and all her generations to follow.*

Several years ago, my husband and I moved to a small barrier island, a sliver of sand and moss-draped trees from another era on the coast of South Carolina. We were refugees from the Northeast, fleeing to the South in search of a slower lifestyle, warmer weather and a new beginning. A few years earlier, I had undergone surgery and a yearlong regimen of chemotherapy treatments for cancer, our gallery business was failing, and we began having serious doubts about the prospect of "having it all." We knew we would have to move to a place that would give us a deeper meaning to our lives—a place where we could reinvent ourselves and start over. We didn't know how or where we would find such a place, but on a muggy, summer day, with all of our possessions, studio supplies, and gallery inventory crammed into two vans behind us, my husband and I headed south.

Where we ended up may not be too surprising. Many people move south. But what resulted from that move would, for us, change the focus and direction of everything. After settling into our new home and finding a new gallery location, I set out to find subject matter to paint. Quite by accident, I wandered into a tiny, dilapidated church one afternoon and met a group of seniors making quilts. Longtime residents of Johns Island, and many of whom were descendants of slaves, this extraordinary group of African American women would soon change my life and paintings in an astonishing way.

One woman in particular, Alfreda Gibbs Smiley LaBoard, would wind her way into my heart and become, I am proud to say, a true friend. Over the next ten years, Alfreda and the other

women at the Center would teach me many of their Gullah customs, an introduction to the language, and several of their traditional hymns and recipes. They showed me their style of quilting, while recollecting stories from a hardscrabble existence only few could imagine. And they would invite me to their "shouts"—boisterous worship services punctuated by rhythmic clapping and foot shuffling as was done by their ancestors.

The Gullah culture and language began as many blacks arrived on the South Carolina barrier islands via slave ships in the seventeenth and eighteenth centuries. Out of necessity, the new inhabitants developed their own language, a unique Creole blend we now call Gullah. After the Civil War, the prolonged isolation of the coastal communities allowed the Gullah traditions of language, music, dress, crafts, and cuisine to remain intact. As mainstream America continues to discover and gentrify these pristine barrier islands, the Gullah way of life diminishes.

The group of women at the Hebron Zion St. Francis Senior Center has changed since I started going there. Mariah is gone, and Emily, Elizabeth, Myrtle and several of the others, and with them all their untold stories. Still, on Wednesdays, Alfreda's husband Isaac drives the squeaking church van down the sandy rutted roads on his circuitous route picking up the women to bring them to the Center. In sequined hats and coiffed wigs, the ladies arrive at the Center, slowly descending from the van, supporting themselves on canes and each other's arms. Inside, on one of the long folding tables, awaits a pan of warm cornbread, its contents always slightly burned on one end, while in the kitchen Miss Mae can be heard clanging together deep metal pots as she washes them in the large sink.

Georgeanna will read from the Bible and lead the devotional, the ladies will sing hymns that echo their forefathers toiling on plantations, Alfreda will give her weekly sermon and announcements, and the women will resume work on whatever quilt is in progress. And in the course of the day, amidst the singing, squabbles and chatter, fifteen or sixteen amazing life stories will begin to unfold, as one jubilant quilt is pieced together.

When I was a teenager growing up in rural northeast Ohio, I would frequently abscond with my mother's car and head north in Geauga county. Only an hour or so drive from my home, laid out neatly over the hillsides in a patchwork of green and gold, were the perfectly maintained Amish farms. There I filled many sketchbooks with drawings of the Amish hitching their horses to the wagons, women hanging laundry, and children skating on the irregular frozen patches of ice scattered throughout the winter cornfields.

It wasn't the "quaintness" of the Amish and the landscape that was inviting for me to paint. That skewed aspect of their lifestyle I would leave to the poster images and cheap trinkets I already saw too much of in the souvenir shops. And it wasn't their attire—the bonnets and beards, black coats and pastel cotton dresses—that interested me, though I must admit painting different textures is fun for almost any artist. What really appealed to me about the Amish was what was inside them. Here, I discovered, were people whose lives centered unswervingly around God and family, self-sufficient from the rest of the world. I wanted to capture as much as I could of it on paper, save it and protect it before it was changed and lost forever. I feared it was a community shrinking acre by acre and generation by generation as the modern world buffed up against it

and frayed its corners. It is for many of the same reasons that I paint the people of Johns Island.

The very first painting I did in the series of African Americans on Johns Island was a painting of Mariah, who was in her mid-nineties at the time. One day at the Center, she was piecing together a turquoise and royal purple quilt, its pattern part planned, part random. Mariah told me she had made over two hundred quilts in her lifetime. Each, like this one, grew piece by piece from a pile of irregular shaped scraps that she plucked from the middle of the table. I sat next to her and sketched while she sewed, and when I was done I showed her my drawing. She laughed and slapped me on the arm with delight as though I had played some happy trick on her.

The next month in my studio, working from my sketch, a photo I had previously taken of Mariah, and the finished quilt which I had purchased from her, I created the watercolor called "Queen." Later, when I delivered the finished product to the gallery our manager expressed doubt that such a painting would sell. And why, if she might ask, did I ever paint it? I remember answering that I didn't know, but it was something I felt I had to do. I went home to paint more.

A person never decides to become an artist. Rather, at some point, one discovers that he or she was already an artist all along. It is in the same manner that artists never choose their subject matter. Instead, our paintings find us. This may sound easy, but it's not. The hard part in all this is opening the door of our conscience wide enough so our ideas can get through and onto the paper. Conventionality, fear of rejection and lack of confidence often keep us from finding our true creative purpose.

I am sure there are many people who still want to ask me why I paint African Americans. The whole lumpy box contain-

ing prejudice and skin color is so awkward to handle that I am sure it keeps many of them from posing the question in the first place. My answer to their question is simple. Because I want to paint. Because I want to feel. Because I once thought I would never make it to my fortieth birthday, and I want to experience every little bit of gritty sand, pungent smell and cock-eyed smile this amazing life has to offer. Next year, I may discover something entirely different and deliciously wonderful to paint. Or rather, it will discover me. I hope it does. Mostly, I want to be grateful for it all, and Alfreda has taught me that. Thank you, Alfreda.

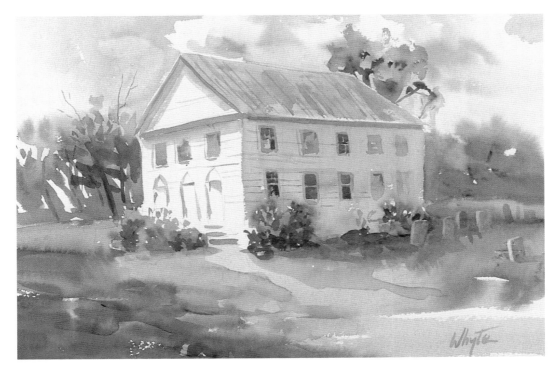

*Hebron Zion*

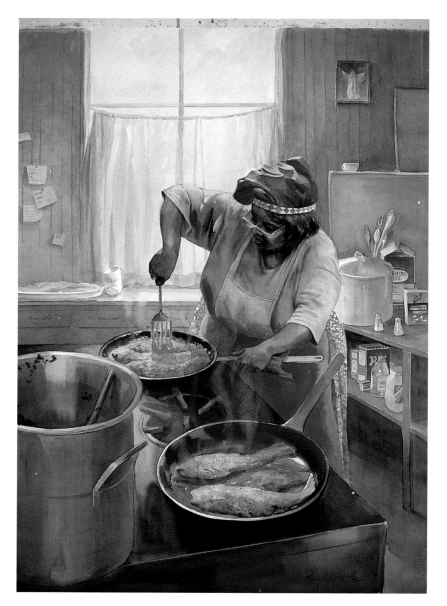

*Fish Fry*

The first time I saw Alfreda, she was hauling a large pan of sloping cornbread from an enormous black iron stove. Standing in the kitchen doorway at the back of an old wooden church, I was witnessing the birth of one of her signature creations: sweet-smelling cornbread that was thick and cakelike on one end, and thin and burnt on the other, a feature caused by the slanting wooden floor underneath the heavy stove. There seemed to be not a single right angle in the whole building, the oldest African American church on Johns Island. It had been built right after the Civil War from the scavenged pieces of a shipwreck, and the kitchen looked as though it had not been updated in a hundred years.

On top of the tilted stove, a large dented aluminum pot bubbled over with pungent spices, and two frying pans filled with a dozen whole fish sent corkscrews of steam right into Alfreda's face as she studied them. All the ladies in the kitchen had little droplets on their faces as they prepared the hot food. I noticed that the sheer curtain over the sink was suspended by a sagging rope across the sash, framing the dusty view to a flat cemetery. Under a large oak, scattered tombstones were spread across the shade, receding in size as the years passed until some became whispers of markers, probably for the generations of Johns Islanders who had come here as slaves. One new headstone was skirted by a splash of red heart-shaped wreaths, orange plastic flowers, and a small decorated clock that bore the time of the most recent passing. Four forty-five.

As the women laughed and spoke, I heard the Gullah language their ancestors spoke, the symphonic blend of European,

English and African tongues that was born in the rice and indigo plantations three centuries ago.

I stepped into the small church kitchen, and a few women glanced shyly at me as they continued chopping and stirring and rinsing. Then, the largest one, the creator of the sloping cornbread, turned around and smiled.

"Hello!" she said loudly, "I'm Alfreda! Welcome." Then she drew me into her large arms and hugged me tight, drenching me with the sweet heat of her apron. I stood as straight as a pole, my eyes blinking.

After a couple of seconds, Alfreda released me, then turned around and picked up a plastic plate from the counter. She plopped on a whole fried fish, thickly-breaded and curled, then a spoonful of macaroni and cheese, some red rice, collard greens, and a large chunk of the hot corn bread carefully sliced from the thick side of the pan. I hadn't even told her my name yet, or explained why I was there. Alfreda held the plate and looked me up and down. I heard her mumble something like "meat on her bones," as she plopped an extra pile of rice on my plate and handed it to me.

"You tote that on over to the table and eat," she said, "We always got plenty. And if we don't, we just adds more water to the pot!" She laughed warmly and wiped her hands on her apron. That was the beginning of our friendship.

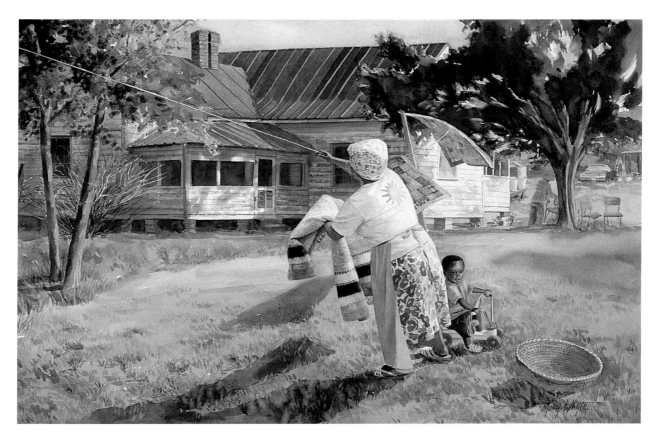

*Airing Out*

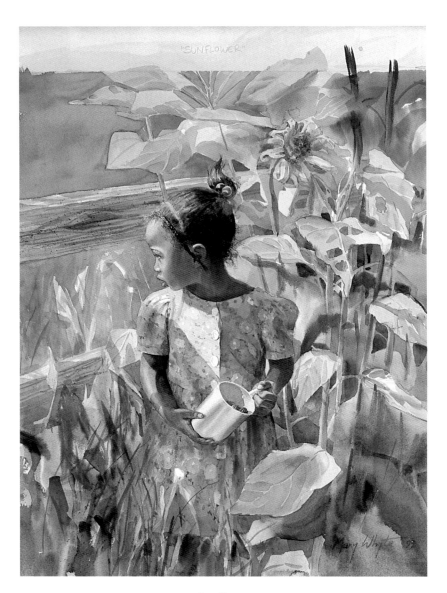

*Sunflower*

The year I was born, 1953, Alfreda was miles away on a South Carolina sea island, already a young woman of thirteen. The eldest of three children, Alfreda lived with her mother, brothers and grandmother in a small wooden shack the size of a one-car garage. Across the sandy road lay the flat expanse of the plantation, row after row of speckled white cotton stretching to the horizon. Every nonessential tree, except for the one that spread an umbrella over the house, had been removed to make room for the crop. In winter, the tiny house was heated by a potbellied stove that squatted at one end of the main room, which served as both kitchen and sitting room. Alfreda's home had no electricity and no running water.

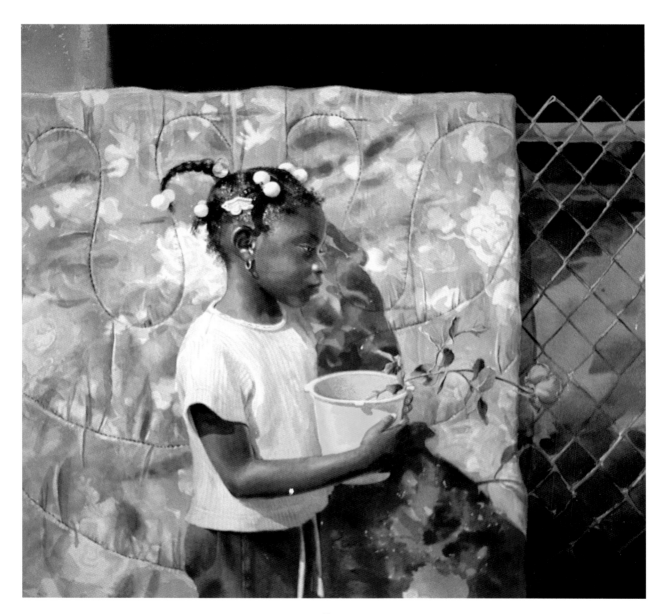

*Rose*

Alfreda was called "Boot" by her grandmother, which I like to think was adapted from Beautiful. Alfreda slept on a cot, under a quilt made from feedsacks and scraps of old clothes. Honey kept Alfreda company at night, the doll her grandmother had made from the tall grass that only grew in the dark soil at the far end of the field. Colorful magazine pages were pasted on the walls to keep the wind from whistling through the cracks. One of them showed the picture of a fancy Ford automobile with tail fins. Another was an advertisement for an electric toaster. *Someday*, Alfreda would muse to herself, *I'll get married and have a toaster so I can fix breakfast for my husband.*

Alfreda hated the fields. Looking back, it seemed that her whole childhood was spent hauling the long sacks heavy with cotton or white potatoes down endless rows to the waiting wagon. Bag after bag of cotton or potatoes, under the hot sun. Alfreda's day began long before sunrise, when she and the whole family would wake up and walk to work in darkness, feeling their way on bare feet along the dirt roads. Under the fading stars, the singing of the other workers already in the fields would drift across the miles of crops. They were the familiar old African songs of the generations before.

> *I'm goin' to set at the welcome table, some a these day,*
>    *hallelujah,*
> *I'm goin' set down side my Jesus, some a these day, hallelujah,*
> *I'm goin' to rock from side to side, I'm going tell Him about*
>    *my trouble,*
> *I'm goin' to see my dead grandmother, I'm going to see all*
>    *the apostles,*
> *I'm goin' to rest from all my labor, I'm going to drink from*
>    *the healing water, one a these day, hallelujah.*

13

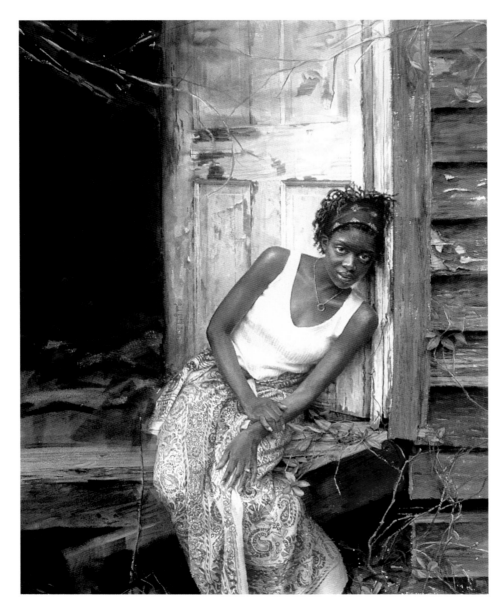

*Waiting*

Alfreda's mother left home frequently during the winter, following the migrant workers as they moved south to pick crops in Florida. So Alfreda and her brothers stayed behind in their Granny's care. Granny was the local midwife on the island, walking from house to house to assist with long labors and deliveries. She boasted of bringing to the world more than two hundred healthy babies. Granny was also the island's only herbalist, creating potions and tonics from berries, roots and leaves gathered in the local woods. These concoctions cured anything from stomach pains to "the vapors."

Alfreda remembered her granny spending hours making a special dark brown tea for one woman in labor. People gave Granny food as payment for her medicinal treatments, and the family ate well. But they had almost nothing else.

"Nothin' but love," Granny would say, tabulating their possessions.

School, a one-room building with a bench for each grade level, was a blessed relief from the cotton fields. But it was miles away, across a rickety bridge on another island. Alfreda had to carry her younger brother, Thomas, because he had crippling sickle cell anemia. Their brother Nickie would carry everyone's books and lunches. Lunch was usually a piece of fried bread, dripping with lard or bacon fat. On special days, lunch might be sweet, sticky pumpkin chips wrapped in brown paper, or horse cake, a thick bread cut into the shape of a two-legged animal, except it had no head.

New shoes were something for the rich or the very lucky. At thirteen, Alfreda wore shoes from wherever they could be found, as did her brothers. Their best shoes were carried to church and put on just before entering the building. When holes grew large, they replaced the insoles with cardboard. Alfreda remembered one pair that her grandmother received in trade from a white lady at the farmer's market in Charleston. They were an old pair of bone-colored pumps, whose high heels were then chopped off by Granny so young Alfreda could wear them as flats. The toes of her new shoes pointed upwards, bringing many taunts from her classmates. Wearing those shoes, Alfreda carried her brother to school on her back every day. Thirteen was a long year.

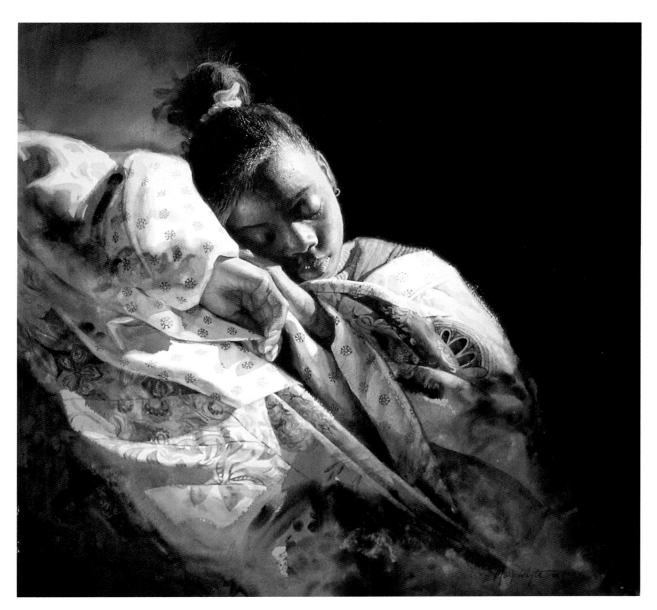

*Dream of the Ancestors*

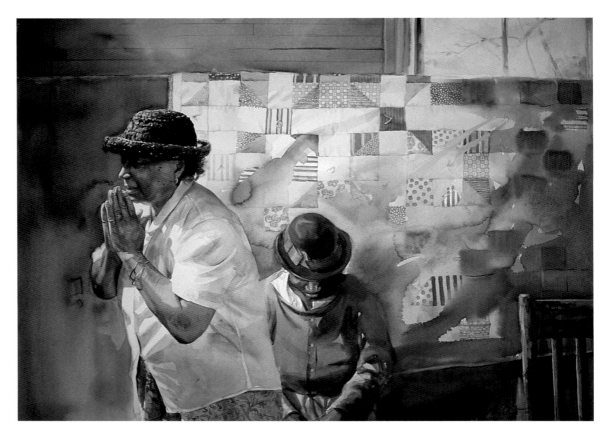

*Devotional*

At the beginning of each weekly meeting at the Hebron Senior Center, Georgeanna's slow, deliberate, half-formed words of Gullah hang in the air as the other women answer back in rhythmic tones of "Yes, Jesus! Thank you, Jesus!" Georgeanna stands at the lectern, which is covered in brown fabric and turned at an angle next to an old television set in the corner of the room. Georgeanna's palms are pressed together as she bends forward to read the words from her Bible, a small crumpled stack of thin pages held together by a leather cover with shredded edges she keeps closed with an old rubber band. Most of the sixteen women are well into their seventies and eighties. They wear unique combinations of the clothes that have come their way: sequined hats and sweatshirts, colorful skirts and white sneakers with the backs cut off so they fit better. The outfits are reinvented every week for this meeting.

Georgeanna finished her prayer and smiled at me, the young white stranger who towered over everyone else. I could tell she was pleased with her reading. When I smiled back at her, she blushed and looked away.

Alfreda rose from her chair and lumbered over to the table where a large quilt was laid out, the current work in progress. Scraps of multi-colored fabrics were sprinkled over the table and onto the floor. Alfreda's smile widened across her shiny complexion as she steadied herself with one hand on the table and looked at me, the newest visitor to the Center.

"Good morning!" Alfreda said. She speaks with an authoritative voice and careful enunciation, which combine with a lilting animation.

Alfreda turned back to face the group of women as they sat and sewed. It was time for her weekly lesson.

"Ladies," she began, "God put us here to help each other. We all need help."

The ladies nodded, and two of them started to rock back and forth as they listened to Alfreda.

"We needs to be thankful for what God give us," she continued. "I just thank God I could get up this mornin' and get dressed, because that old arthritis really actin' up. But God gave me the strength to keep goin', so here I am. We all needs to be thankful. That's all. Be thankful for what God give us."

Soon I became a regular at the Hebron Zion Center, and I began to look forward to Alfreda's informal talks about the lessons of life. Sometimes she gives a cheerful pep talk of encouragement, and another week she might sound like a stern schoolteacher berating us for not doing our homework. Even though I am a Yankee stranger who was simply there to sketch and get ideas for paintings, Alfreda's message found its way into the darkened crevices of my soul. I only intended to be a passive observer; still, Alfreda's wisdom reached a part of me that had never been touched before. Every week I returned to my studio with new sketches, and a new message from Alfreda's sermon penciled into a corner of my sketchbook. I could sense my paintings beginning to change.

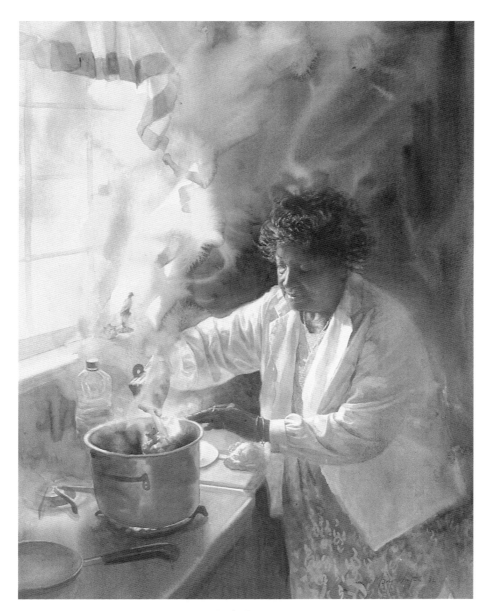

*Early Rising*

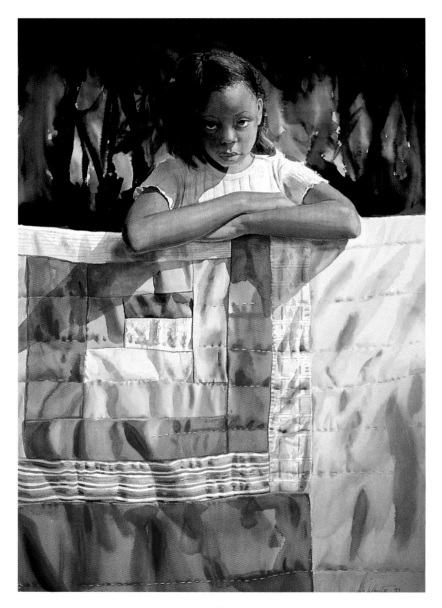

*Mariah's Quilt*

The women sew quilts to raise money for the Senior Center. All of the fabric is donated from people cleaning out their closets or from designers' cast-off sample books. Now and then, among the overflowing garbage bags of donated fabrics, the women will find someone else's unfinished quilt, a curious project never completed, its meaning and maker a mystery. The women's quilts are lined with old blankets or large rectangles sewn from old clothing scraps. The backs of the quilts are whatever single piece of material is large enough. If there is enough money in the "kitty," they might even purchase new cotton from the fabric store.

Quilts are displayed around the room on special occasions, such as a fish fry or whenever visitors come, in hopes that one will sell. Other times, several quilts might be taken outdoors and hung on a clothesline near the side of the road, their corners lifting in hopeful greetings as cars whoosh by. In addition to the traditional quilt designs, such as the "Starburst" or "Crazy Mixed-up" quilt, the ladies have patterns such as the "Old-timey" quilt, the "Bandana" quilt, and the "Mariah" quilt, which is any quilt that has a diagonal design in it. Sometimes they are known only by their colors, such as the "Red-and-white" quilt, or the "Big Blue" quilt, or the "Smallsmall Blue" quilt.

I looked forward to watching the quilts expand every Wednesday. After the devotional service, I served coffee and cornbread and then sat down to join the women at one of the large tables. Sometimes I threaded needles, or cut shapes of brightly-colored fabric, listening to their conversations, asking questions.

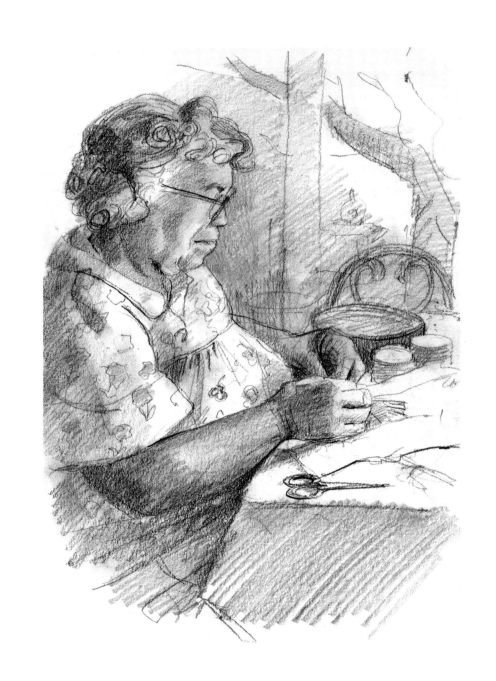

I watched Hortense as she carefully folded and pinned small circles of fabric, while Alfreda sewed and talked about her Granny.

"She was a midwife and a root doctor," Alfreda said. "She could go out in the woods and pick plants to cure any ailment. Any ailment!"

"Mariah could do that too," Mary Simmons said. "She once met a couple married five years, couldn't get pregnant. Mariah make them up something, I think it was white oak bark and red oak bark. You know—tea. They went back home to New York City and within three months, the lady was pregnant."

"I remember I had a cold. Granny go out and pick the big leaf off the awl bush," Alfreda continued. "You call it a castor bean bush, we call it an awl bush. Anyway, she lay this big leaf on my chest, stay there all night, and in the morning the leaf was all shriveled up! But I was completely well."

"Is that the same plant where castor oil comes from?" I asked Alfreda and Mary Simmons, wondering if *awl* and *oil* were the same thing. They looked back and forth.

"Yeah, I think so," Alfreda said, "but the awl comes from the bean, and my grandmother, she used the leaf. Huge leaf, big as this." She spread her palms out the size of a dishtowel.

"That Granny, she taught me everything. She had the motherwit," Alfreda said. The others nodded and murmured in agreement.

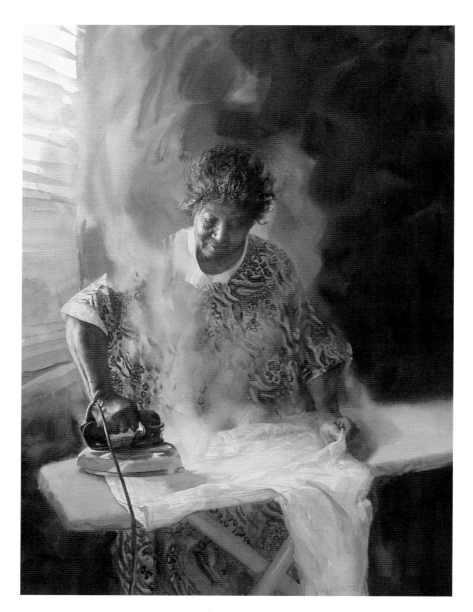

*Steam Iron*

One week I arrived at the church early. I could tell that I was one of the first ones there because Isaac's van had not yet arrived from picking up all the ladies. I recognized Alfreda's car parked in the shade of a large tree, and I found her back in the kitchen putting a pan of bread pudding into the oven. I leaned up against a counter while she stood up and stirred a bubbling pot on top of the stove. She turned down the gas flame and motioned to the table.

"Man, I got to sit down," she exclaimed. "I been on my feet since six o'clock this morning."

I pulled two chairs over to the old folding table and we sat down.

"How's Nana?" I asked. Alfreda's mother Nana was bedridden, one of several family members Alfreda cared for.

"Oh, she better," Alfreda started to smile. "She up early this morning wanting grits. And then the grans be wanting breakfast too." Several of her daughter's children also lived with Alfreda.

"It seems I always be doin' for someone."

"You take care of a lot of people," I said.

"I just pray every morning that God give me strength," sighed Alfreda. "Every day a battle, especially with the grans. They need constant lookin' after. Constant. And there so much bad influence out there. I tell them they can't do like the other children do, the ones who all act up. It a battle every day, keepin' them little ones honest and truthful, and havin' them do what right. It somethin,' just trying to teach them good manners. I tell them like my Granny told me, that manners will

take them places money never will. That it important to do right and be respectful of others. To be truthsful. It not easy. That Satan always at work! He keep pullin' at the children, and I keep pullin' them back."

"Are they doing all right in school?" I asked.

"I be after them all the time about their homework. I have to sit with them every night, makin' sure they do it."

"You do their homework with them every night?" I asked, picturing her leaning over schoolbooks and math papers, checking letters and figures.

"It's just like when I taught my brother Thomas to read. You know, he reached a time when the sickle cell so painful, he had to stop goin' to school!" I imagined Alfreda as a young adult, and wondered how many children she had taught to read since her brother.

"I'm tellin you, it's a time," Alfreda laughed. "Between Nana and the grans, I got me a time."

She looked toward the stove.

"Child, go on over there and stir those collards for me."

"How about I check the bread pudding too?" I replied.

"No," she sniffed. "I'll tell you when it done. And don't forget to take a piece home to Smitty. And rub his head good, too!" Alfreda knew my husband Smitty adored her cooking, especially her bread pudding. Smitty looked forward to Wednesday evenings, when he might find a small tin-foiled package in our refrigerator.

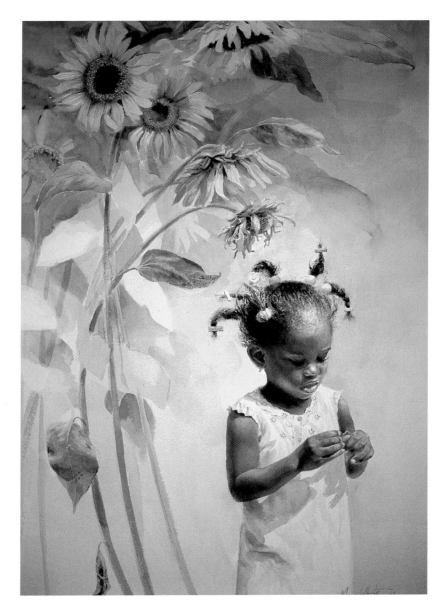

*Inchworm*

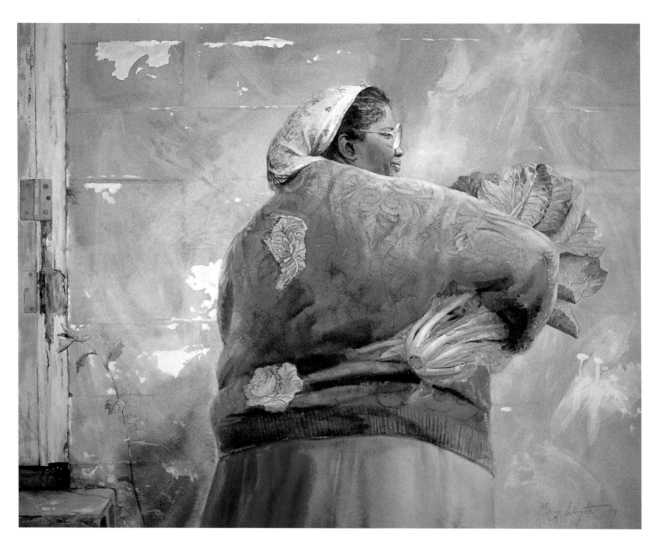

*The Hugo Sweater*

I arranged with Alfreda for a good time to come to her home and paint her. I drove the eight miles up Bohicket Road and turned into her driveway, stopping in front of a rectangular cinderblock house painted a bright turquoise blue. Neat rows of okra led right up to the front door. She had a makeshift vegetable stand at the end of her driveway near the road with a "Freda is Open" sign nailed high on a tree, always waiting for customers.

Alfreda was outside behind the house, stringing wet laundry on dozens of clotheslines that surrounded her like a spiderweb. Six-foot poles propped up the line at intervals where the soggy clothes would have otherwise touched the ground. The plastic laundry basket on the grass was still full, spilling over with jeans and towels and tiny socks and shorts in primary colors. Alfreda was wearing a rag tied around her head, and an olive cardigan patched with large pink floral organic shapes.

"Tell me about that sweater," I said.

"This?" she said, looking down and patting her front. "This my Hugo sweater."

Alfreda told me a story about hurricane Hugo, which had torn across the island in 1989. When my husband and I moved here two years later, its devastating scars were still everywhere. Many buildings in Charleston had been destroyed, and most Johns Island homes had been severely damaged. Alfreda's house lost a large section of roof, which sent buckets of rain inside, ruining almost everything they had.

During the clean-up after the hurricane, Alfreda's church had received boxes of clothing donated from all over the coun-

try and distributed them to members of the congregation. When Alfreda and her family opened their box, it contained brand new sweaters of all sizes and colors. But holes had been slashed into each one, apparently so they couldn't be sold.

I was dumbfounded, and told Alfreda that I couldn't imagine losing everything, and then receiving goods that had been damaged on purpose.

"Child, you best be getting over that one," she said. "Every time someone do you wrong, you can't keep goin' on about it. And you can't be worryin' about what other people have, either. People always worryin' about someone else got more than them. None of this belong to us anyway."

"What do you mean?" I asked.

"It's God's," she replied, bending down to pluck a blue sock out of the pile. "All this belong to God. Everything. Even this ol' raggedy sweater. It ain't really Freda's sweater. No ma'am. It belong to God. I just taking care of it for him."

I thought about this for a moment, watching her clip a sock to the line.

"That's why we supposed to share," she continued cheerfully, "If I got something and you need it, I give what I have to you."

"Well, I sure wouldn't give someone something with holes in it," I said.

"It not so bad," said Alfreda as she looked at her sleeve and ran her hand over it. "Besides, I made flowers and patched over the holes."

I looked again at the irregular shapes of cotton fabric that had been carefully applied with black stitches.

"Flowers," smiled Alfreda, "just like in the Garden of Eden."

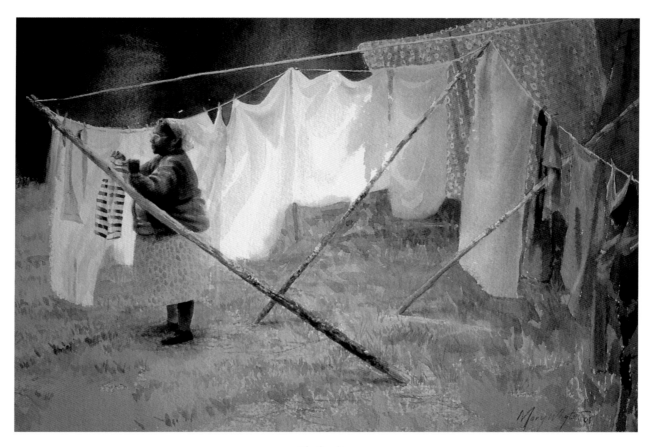

*Clothesline*

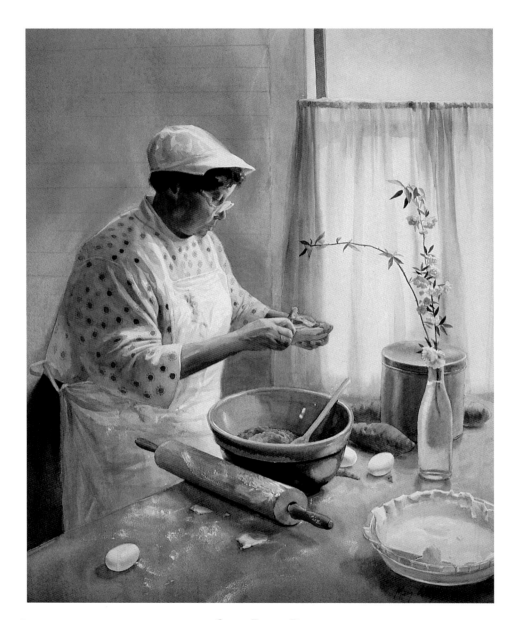

*Sweet Potato Pie*

One day, I asked Alfreda for the secret to her sweet potato pie.

"No, no, there ain't no secret," she answered, leaning back in her chair. "It just whatever you have on hand. If you got it, you put it in. I don't never write anything down, but I can give you a recipe."

I tore a page out of my sketchbook and wrote the list of ingredients as she recited. A couple of sweet potatoes, a spoon of lard, dash of spices, one egg, a scoop of sugar, a scoop of flour.

"A scoop?" I asked. "How much is that?"

"Oh, you know," she answered, looking down into her curved palm. "About a cup I guess."

"How much is a spoon?"

"A *spoon*," she emphasized, as if I didn't hear her. "A kitchen spoon."

She continued on. "You make the dough by putting it on your table with a dash of flour, pat it out and roll it over two or three times with a jar. And then bake it."

"For how long?" I questioned.

"Until it done," she said simply.

"Well, about how long is that?"

Alfreda leaned back in her chair and cut her eyes at me. I knew she must have been thinking I was going to be a real project.

"I guess thirty-five or forty minutes. Long enough to fold and tote in the laundry."

"But how do you know it's done?" I asked, this time not daring to look up from my scribbling.

"You stick a straw in it and if it come out clean it done," she answered, pushing her chair back a bit.

I had a fleeting glimpse of myself going to the landscape department of Home Depot and asking to buy "One straw, please." I looked up and saw her grinning broadly.

"An' child, le' me tell you. That pie is so good it make you want to slap your mammy and reach back for your pappy!"

While we were at it, I also coaxed from her ingredients for okra gumbo and spicy collards. I think she was pleased that this Yankee was finally coming around to cooking real food. The ladies at the Center laugh whenever the white women on soap operas serve little salads for lunch, or tea sandwiches and little vanilla cookies.

"That ain't fit for a dead cat!" they'd squeal with laughter.

Later that year, I bought Alfreda a Christmas gift—a shiny new cooking pot with a lid. Inside, I put a five-pound bag of white rice. More okra gumbo for all those grans. On Christmas day, Smitty and I, as well as my brother, Bob, and his wife, drove over to Alfreda's house. Her living room was transformed; a dark cave with walls of painted cinder blocks had become a festive mayhem, with sparkly lights and torn wrapping paper everywhere. We stepped over open boxes and ribbons to exchange hugs and greetings. In the corner stood a plastic bucket filled with sand, holding a spindly Christmas pine that looked like it had been cut near the river. Its few drooping branches were decorated with brightly colored paper ornaments made by the grandchildren. Alfreda was wearing her robe, still opening presents. She opened one, a small plaque made by the children that said "World's Greatest Mom."

One child crawled into my lap and another into my husband's lap, their faces sticky from candy canes. I handed Alfreda my gift and she let out a great "whoop!" when she opened it. After a few minutes, I leaned over and asked how the morning had been.

"Oh, man!" Alfreda exclaimed. "The grans was so wound last night, it took forever to get them to bed. All night, they be hollerin' at me, is it time to get up yet? And I keep tellin' them to go back to sleep. And, finally, I said it all right to get up, and they come runnin' in here so fast they knock the tree down!"

I smiled, thinking about our own quiet ritual at home, lighting candles and listening to "The Nutcracker." After an hour, we rose to leave. Every member of Alfreda's family hugged every member of mine. Alfreda called to one of her grandchildren in the kitchen to fetch one of the sweet potato pies. He came out with a pan covered in foil.

"It not much," Alfreda said as she took the pie and handed it to me, "but it made with love."

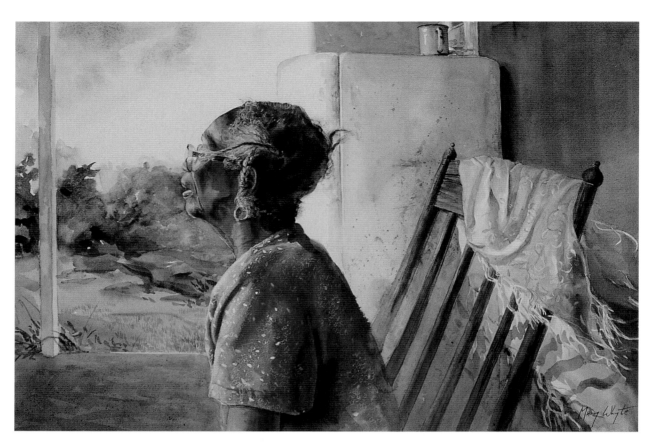

*Sing Unto the Lord a New Song*

At one of my first visits to the Hebron Center a regular named Mary Simmons introduced me to her grandmother, Mariah. She was ninety-six, with a regal bearing that was breathtaking. I had to ask her if she would pose for me. Mariah lived in a brown trailer at the far end of a mile-long pair of sandy wheel ruts, almost to the river. On the day I came to paint her, she emerged from the front door wearing a blue dress with tiny white dots, a print I recognized from one of the quilts in progress at Hebron Zion. To me, it looked like an indigo sky with a million glittering stars. She was wearing an orchid pink straw hat, brown, flat-heeled shoes and carrying a small white handbag. She marched through the grass directly to the passenger door of my car.

"Mariah," I stopped her. "Do you mind if we just stay here, and I paint you on the porch?"

She nodded slowly and turned back to the house. I moved the two chairs around on the small veranda. Then we both sat down and I went to work under the diffuse light of thick pale clouds. We listened to the bees buzzing as the breeze silently lifted up the fringe on Mariah's shawl. She stared out towards the field with the eyes of a queen overlooking her realm.

I have learned, over the years, that the sounds of nature are my best accompaniment—wind, water, birds, rustles and sighs. Once in a while a few words might be exchanged, we'll take a brief break, the phone rings. But for the most part, I and my subject both work without saying much. Mariah, however, began to hum, and to rock slightly in her chair. I looked up at her.

"Mariah, do you have a favorite hymn?" I asked. She

paused for a second, and then started to reply.

"Mm-hmm. 'A Charge to Keep I Have'," she said. I asked her if she would sing it.

She looked away and swept into a plaintive song with a powerful alto that caused the hairs to lift off my skin. I was spellbound as Mariah leaned her face towards the sky and closed her eyes, filling the air with her soulful voice, accompanied by a chorus of insects buzzing in the fields.

*A charge to keep I have,*
*A God to glorify;*
*A never dying soul to save*
*And fit it for the sky.*

Mariah sang several verses, and ended with a final, fading note into the gathering breeze. Then she folded her hands in her lap and leaned back, humming and rocking once again, her eyes still closed. I felt as though she should be out of breath, but she didn't even sigh. As the song ended, I knew my drawing was finished and, thanks to Mariah, I had created my own work of praise to God, in only a few minutes' time.

"Here, Mariah," I said, "Take a look."

I turned the image around, and she sucked in a quick deep breath. Then she leaned over and slapped my forearm, laughing hard.

"Wha-ha-ha! Is da' me?" she cried in delight. The matriarch was a little girl in the face of her own image in profile. "I ne'er saw me look like da'!" She touched the back of her head and moved her fingers over the narrow braid there, the braid she knew well but had rarely seen, even in the mirror.

"Praise Jesus," she whispered to herself, with wonder.

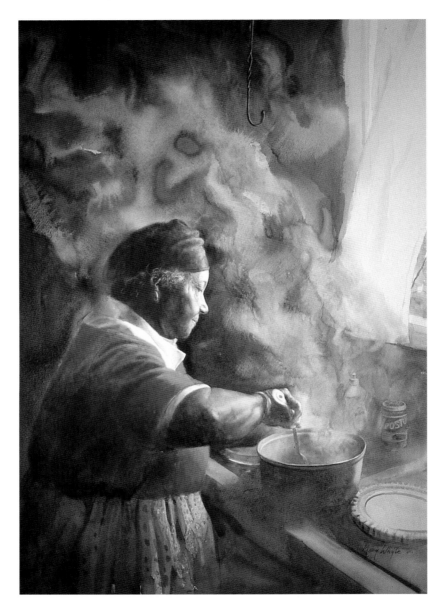

*Sister Heyward*

Two years after I began going to the Center the women relocated their meeting place to a modern new church just up the road. They seemed to welcome the comfort of air-conditioning, and in winter months the central heating in the new building was a blessing to arthritic joints.

I pulled into the dirt parking lot of the new, modern Hebron Zion Presbyterian Church. Down the road the old building still stands as a preserved relic. The new church is solid red brick, with large rooms for the pre-school and after-school programs. That Wednesday, the hallways were filled with St. Patrick's Day decorations and children's drawings. I could hear children in the classroom, and passed by Miss Mae cooking and singing in the new kitchen. She comes in at five in the morning every day to prepare breakfast and then hot lunch for the children. Today's menu was roasted turkey wings in gravy, rice, lima beans and corn, bread, and an enormous blackberry cobbler. In addition to feeding the children, Miss Mae is also responsible for serving lunch to the senior citizens who meet here for praise and quilting.

The meeting began at ten o'clock, with a devotional led by Georgeanna. She turned down the volume on the TV set in the corner. The ladies came to order, seated around three large folding tables.

"O Lord, thank you for bringin' us together today."

A few ladies punctuated her words with an "Amen."

"You didn't have to do it, but You did. You got me up this mornin' filled with energy for a new day."

"Amen!"

"You helped me get up, put my clothes on and come here one more time."

"Amen!"

"Help us to be strong, and serve you in the goodness of your light.

"We pray for those who are sick, like Ethelee, who need your help to get well."

"Uh-huh."

"And we thank you for this nice day. We came here, we're gonna eat good, and you didn't have to do it!"

"Amen."

"But ya did."

"A-men!"

The others joined in, banging on the tabletop with fierce intensity that belied their delicate appearances. Florence began to sing, as did Miss Emily, in a royal blue knit beret and teal vest that added dash and substance to her pale skin and thin arms. Sarah, in powder blue sweatpants, was one of the two smokers in the room, and she was berated by Alfreda and Mary Simmons every time she stepped outdoors for a cigarette. Mary Simmons, who is Mariah's sixty-year-old granddaughter, has enormously powerful arms and shoulders filling a blue turtle-neck. She still acts as the group's treasurer, carefully filling in "$5.00" each month in the red leatherette diary next to each member's name. As they sang praise with Florence, picking up the tempo by slapping their palms on the sewing tables, a grainy TV commercial showed a happy housewife in an impossibly large laundry room, pouring Tide in a washer.

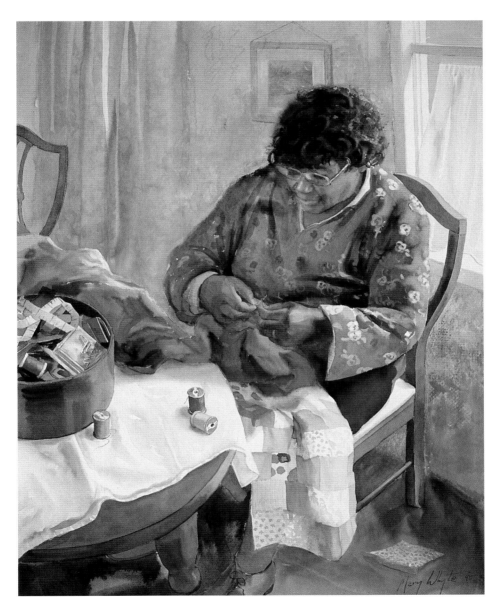

*Threading the Needle*

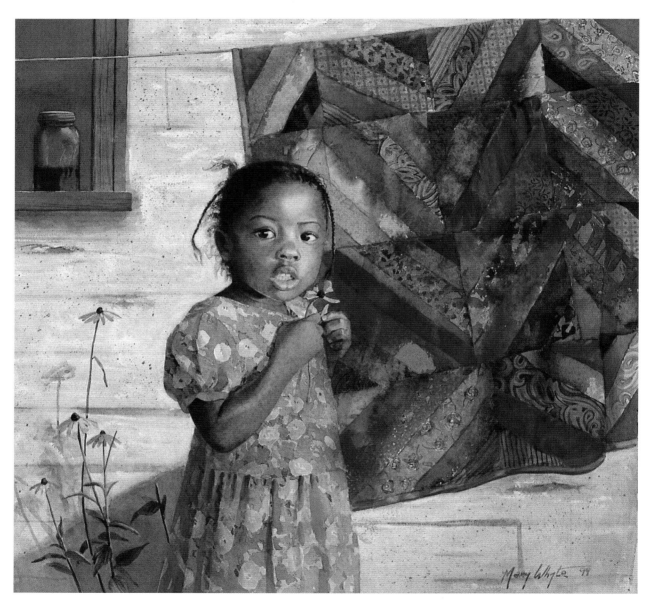

Black-eyed Susan

During one of our painting sessions, I asked Alfreda about the place where she grew up. I encourage her to write down all these bits of information passed on by her grandmother, memories to pass on to her own grandchildren. Like so many remote cultures, this sea island is being paved over by the influences of mainstream America, and I feel a sense of urgency to capture this before it's gone. It's why I paint the Gullah residents here, as I once did the Amish in the Ohio countryside. I am grateful for the chance to be a link that might allow these images to endure. And I want to help Alfreda preserve her heritage for her grandchildren. When I was picking up new sketchbooks at the art supply store, I bought a spiral notebook for her. Unlike many of the other older women at the Hebron Center, Alfreda can read and write fairly well. She attended college for a year, hoping to become a nurse, but a back injury prevented her from continuing. I ask her every week if she's written in the notebook, but it's rare that Alfreda ever has the time to do it.

I suggested we spend one afternoon visiting the plantation where she and her brothers had grown up. I brought my camera and Alfreda wore a beautiful bright purple and blue caftan for the occasion. I was also hoping this visit might inspire her to write some things about her life. As we crossed the creek onto Wadmalaw Island and turned into a sandy road, Alfreda told me that this was the road down which she'd carried her brother to and from school. We hadn't asked permission to drive onto the private property, but it seemed unlikely that we'd run into anyone. The corn was weeks away from harvest.

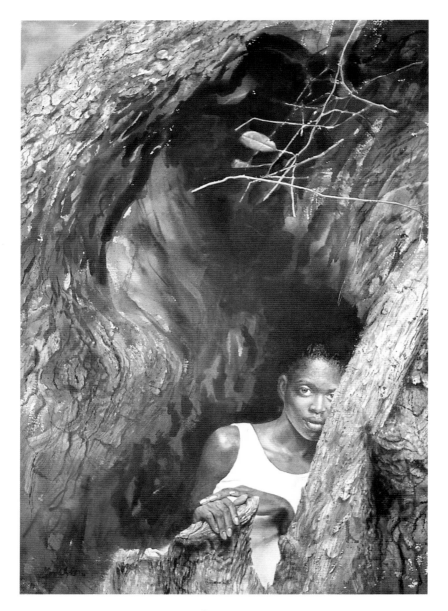

*Raccoon*

As we emerged from the rows of corn, the ground opened into a flat green field, stark and empty. I'm not sure what I'd expected, but I suppose I thought it would be a more romantic picture. This place wasn't lushly overgrown with the forgiveness of time like so many parts of this island, but submissive and dusty under the beating sun. We took another dirt road, then backed up when Alfreda pointed out a narrow sandy lane. We finally pulled up in front of a tiny peeling gray shack. The front door yawned open, revealing bare floorboards and a sunless interior. A massive oak tree shielded the house from direct sun, but hadn't quite kept out all the harshness of the past.

"Back then we had no idea we was poor," Alfreda said. "We was just like everyone else. Besides, we had so much love, nothin' else mattered. How can you think of yourself as poor when you have everything you need? The rich folk always worryin' about gettin' more money. All they really get is more trouble. I'm tired of people talking about rich and poor. They got no idea what it means."

I wouldn't call myself poor, by any means, but I'd done my share of worrying about money.

"But wasn't living here…hard?" I asked Alfreda.

"We may have been poor, but we weren't fools!" she replied. "We ate good in the summer and stored up for the winter. We banked potatoes and smoked meat to hang. We always had something to wear. It may not have been fancy, but it covered what needed coverin'." A smile crept to her lips.

"And when the clothes couldn't be worn anymore, they got made into a quilt! And when the quilt got wore out, it got made into the insides for another quilt. And when that wore out, and all we had left was holes, we made something out of the holes."

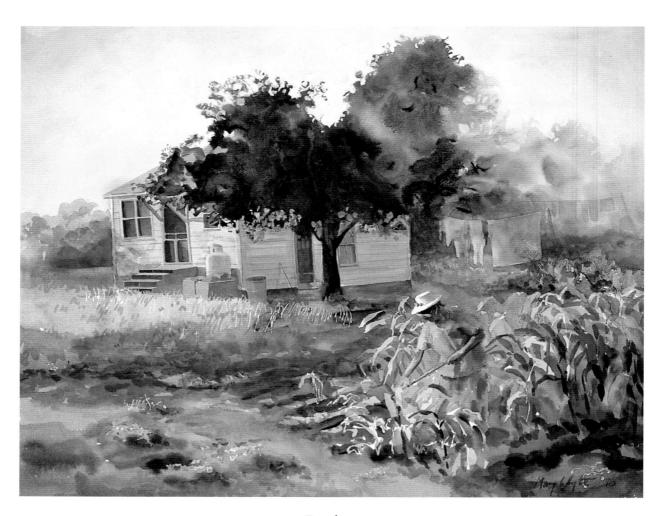

*Dayclean*

Alfreda and I stood in the sandy wheel ruts, fifty feet from the vacant shack where she had lived as a child. We had come back to the plantation where she and her family had worked backbreaking hours picking crops. She and I walked under a massive oak tree under which little Alfreda and her brothers would sleep on hot summer nights when it was too stifling to sleep indoors.

"Oh, child," she said to me, "Would take me a lifetime to tell you how hard life is. I always thought that when I got to be an old lady, I wouldn't have to keep clawing and scratching for every little thing. But here I am, and I got to claw and scratch just to get by, every single day. But everyone got hard times. Some just got it harder than others. No one get through life clean."

Alfreda waved her hand at a blade of tall grass.

"People get swallowed up by Satan," she continued, with more animation. "It not the hard times that bring a man down! It all whether he anchored in Jesus. Yes, ma'am," she lowered her voice, "like the song says, if you not anchored in Jesus, you surely drift away."

I was reminded how all the women at the Center had shared their stories with me as I painted them. Stories about burned-out trailers, lost jobs and drowned children. But they always had this look in their eyes, a look I now saw on Alfreda's face, as if they were seeing something far across the horizon, something I couldn't see.

Alfreda and I walked over the weeds and into the deserted house. Sunlight peeked through a single rear window, and I

could see the circular indentation in the floor where the potbel-
lied stove once stood. I inspected the walls closely, to see if I
could find any of the magazine ads, but all I found was bare
wood with the carved initials of more recent residents. Alfreda
pointed to the corner where her cot had been, and where the
table had been in the center of the room. She then turned back
to the doorway and looked out into the corn field. I moved
over and stood next to her, watching the sun stream through
the oak leaves.

"You keep worryin' for the wrong thing," Alfreda said. She
put her hands on her hips and stretched her back. "Money
nice, but it not the answer. You let God love you like he want
to, and you got nothin' else to worry about."

"God love us," she continued, "That's all He want to do.
And He want us to love each other, too, like he love us. Quit all
this fussin' and fightin' all the time. Help each other. We got to
help each other. That what God want."

Holding onto the doorframe, Alfreda swung a leg out and
lowered herself onto the grass. Then she added, "And if some-
one want to help out ol' Freda and give her a few dollars, that
be okay, too."

We walked past the car and down the narrow lane. We
came to a spot where several large oak trees cast wide blue
shadows. Alfreda stopped and looked up at one tree that was
taller than the rest, with limbs that reached across the road. She
had once told me about a tree, a tree where several of the
islanders had paid their final debts to the plantation owner. She
did not witness this herself, but her mother had. I followed her
gaze to the high limb over the road. Then she patted my arm
and kept walking. For this wound, too, she had made a patch
in the shape of a flower, and mended over the hole.

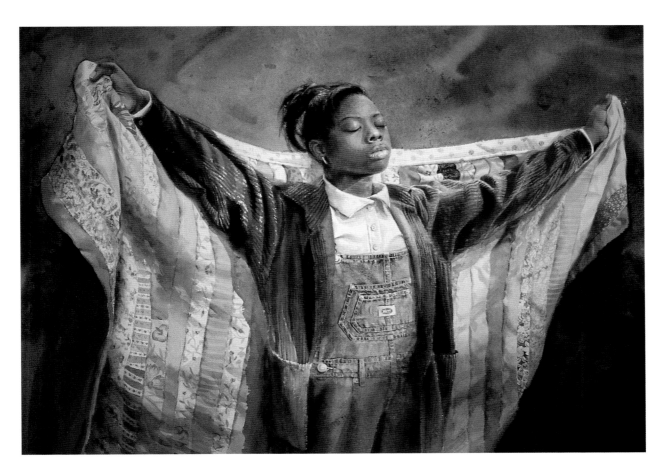

*Angel*

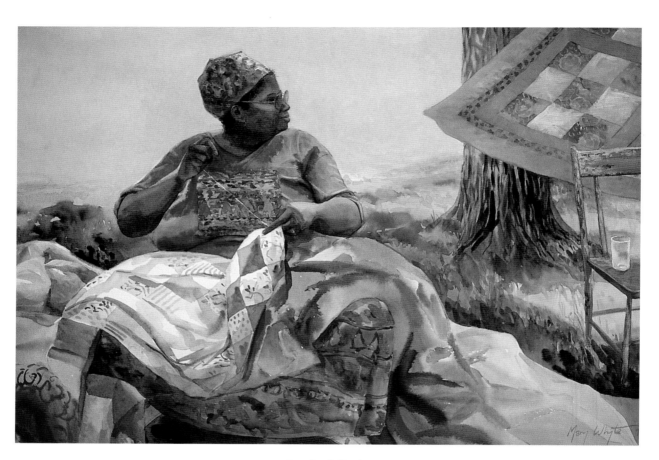

*Patch of Shade*

One morning, Alfreda and I drove two hours to Columbia to see an exhibition of African American quilts at the State Museum. It was a rainy day, and we were the only ones there to see the quilts.

The entrance hall to the exhibit was dimly lit, with cavernously high ceilings. We walked into the first room where the quilts were hanging on large gray panels, each a square or rectangular jolt of brilliant color which emanated outward. Awestruck, I looked around at all the quilts, life inspirations distilled and boiled down into abstractions of fabric and thread, their colors and textures erupting like the rays of a dozen suns into a chorus of "I am."

Alfreda went from quilt to quilt, inspecting them closely. She clucked to herself about their patterns or craftsmanship. She bent down and lifted the corner of a quilt made from old trousers and shirtsleeves. She wanted to look at the back of the quilt.

"Alfreda," I whispered, my eyes darting from doorway to doorway to see if a security guard was watching, "You're not supposed to touch the quilts!"

"Why not?" she asked, straightening as she turned to look at me.

"Because this is a museum, and you're not allowed to touch things in a museum."

Alfreda placed her hands on her wide hips, rocked back and tilted her head to look at me again.

"Well, excuuuse me!" she said loudly. "Now, how am I supposed to look at the quilts, if I can't see the back of em?"

She had a point. After all, quilts were meant to be touched. Indeed, how were we supposed to appreciate the quilts if we couldn't look at both sides? I turned around, gazing at the collection of unique works that had traveled from meager beds to these soaring museum walls. I wondered what their creators would think of their worn and tattered household linens transformed into untouchable works of art, revered masterpieces.

Alfreda moved on, into the next gallery. She looked at each quilt, and carefully read the labels on the wall next to every one. I smiled to myself as she ran her hand over a brilliant yellow and orange quilt, and then flipped over the corner to look at the back. She knew where the artistry was revealed. I reached out to touch a quilt with a midnight blue madras border, and I pulled it away from the wall to peek behind it.

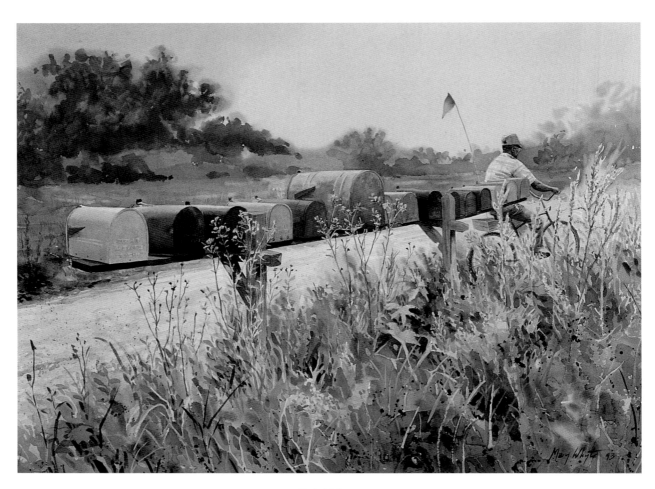

*Goin' Home*

One Wednesday, it all exploded. I arrived late to the Center, slipping in unnoticed in the middle of a heated debate. I quickly sat down on a folding chair near the door, my heart beginning to race. I knew what they were discussing, because a friend had called that morning to tell me about last night's public meeting, held in our own church. The topic for discussion had been the widening of the road to create a bike path, one that would cut through the front yards of everyone on Bohicket Road, including Alfreda's vegetable stand. The ladies at this forum had been chastised when they'd voiced their concerns.

"You people have no right to complain," a middle-aged white man had retorted, jabbing a finger toward the ladies. "If it wasn't for us you wouldn't have anything!"

The women had been stung into silence the night before, but their fury was let loose in the sanctuary of their own church. The indignation and anger rose like steam to the ceiling. It swirled through the room without anywhere to escape. Then Alfreda stood up, her eyes sweeping the room, right past me with a coolness that made my body tense.

"It's the same thing over and over again," she declared, slicing her hand through the air. "We been living here all our life, and the rich politicians come in and tell us they're gonna make things better. We all gonna be rich! Then, before you know it, the white folk be driving up and down the road in their big, fancy cars, buying up everything in sight!"

A few women started slapping the tables with their palms in heated agreement.

"All these new homes going up, big houses and golf places," Alfreda continued, "and they all keep telling us there's gonna be new jobs, with big money for us. And here we all are, just itty-bitty folk with nothing."

The ladies nodded and slapped the tables.

"You would think that with all the money coming in, something trickle down to us. But no. Nothing. Not one drop of nothing come trickling down to us. And the rich folk just go about their way. They go right past us, taking our land and raising our taxes and moving us out of their way."

Ethelee stood up.

"In the end, they's white and we black," she shouted. "Don't nothing ever change!"

The ladies shouted "yes!" and "mm-hmm," and then both Ethelee and Alfreda sat down. The room slowly hushed, as if they all suddenly remembered that I was in the room. I had once felt like their cautious toehold into a world they didn't know. My willingness was the tiny white branch, just sturdy enough to stand on. But now my whiteness resembled that of the scolding man in the church the night before. My church. Thoughts tumbled through my head as children from the daycare center played noisily outdoors. I tried to single out one thought that I might share with the group, something that could force it all to make sense. I wanted to say something that would wash away all the mistakes of the past, like wiping the color off my palette at the end of the day. I felt Alfreda's eyes turn towards me. I sighed and looked down at the floor.

"Ladies," Alfreda said quietly, her eyes resting on me, "We have a job to do. Let's just keep our eyes on Jesus today, and our minds on this quilt."

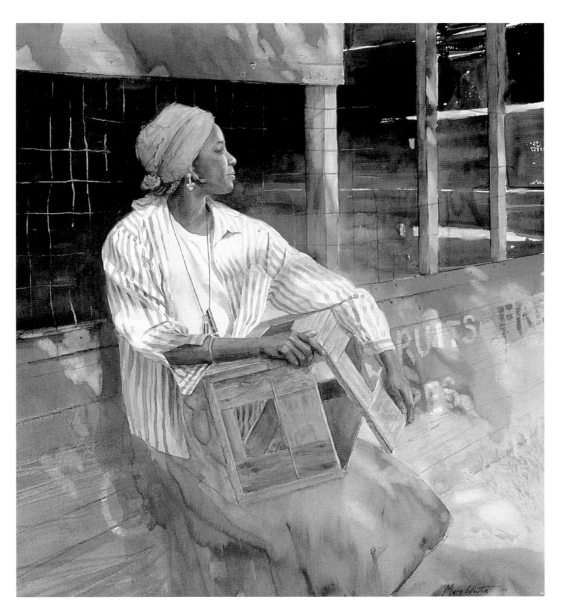

*Road Stand*

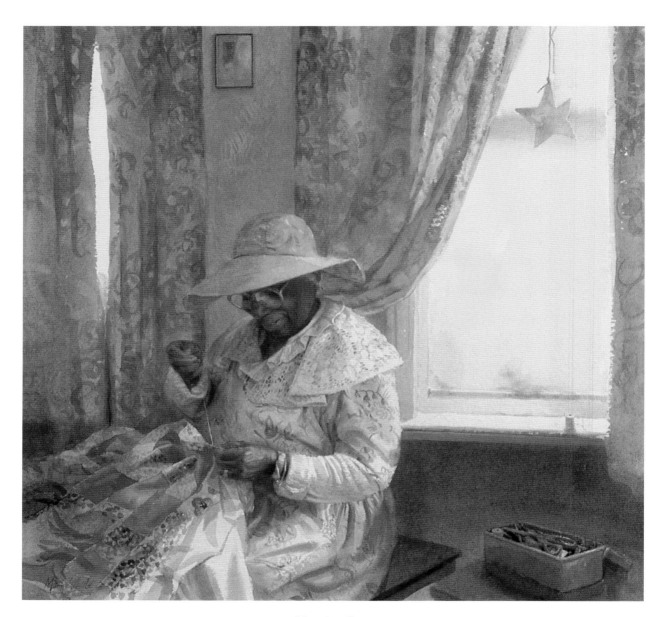

*Morning Star*

One June afternoon, the whole group took a field trip to Edisto Beach. Isaac drove the church van and I drove another, squeezing in a number of adults and children. The children carried bathing suits but the ladies were dressed in their finest Sunday attire, because they were going to share a picnic and afternoon bingo with a seniors group from Edisto Island.

In between hugs and shrieks of old friends reuniting, we laid out the food. The picnic tables were covered with red and white tablecloths, where we unloaded boxes of fried chicken, potato salad, cornbread, green beans, and macaroni and cheese. The Edisto ladies had brought coolers of ice and soda, which they set down beneath the shade of a large oak. At the center table reigned two large cakes with yellow icing.

After lunch, the tables were cleared and we pulled old bingo cards out of cardboard boxes. The boards were worn and faded, but still had little pink plastic windows for covering up the numbers. The prizes were set in a pile on one table, wrapped in newspaper. The children played in the nearby surf, squealing with delight as their brown bodies glistened with foam and wet sand.

I sat down on a bench next to Emily, who had politely declined a game board. I put my own board in front of her and asked her to help me play.

"Look, Emily," I said as the first number was called, "We have B-6." She peered through her thick glasses as I slid the pink window over the number.

"We have I-12 too!" I said. Emily reached out and pushed

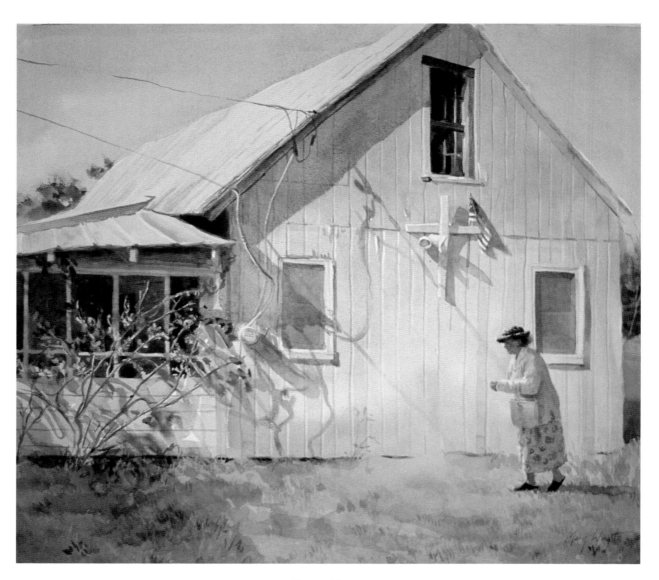

*Praise House*

the window over. She concentrated on listening to me repeat the numbers, her thin finger poised over our game board. After a while, I pointed to a pink row.

"Look at that!" I said to her.

Emily looked at me and mouthed a word silently.

"Say it again!" I replied.

"Bingo" she said softly.

"They can't hear you," I said, "The caller has to hear you."

"Bingo!" Emily shouted, jumping up and knocking over her iced tea. The group applauded and the director handed Emily a prize. Emily carefully unwrapped the newspaper and lifted out a porcelain teacup with pink roses painted on it. Emily ran her hand over the cup and then carefully wrapped it up in the newspaper, placing into her canvas handbag. She put the bag on her lap where it stayed the rest of the afternoon.

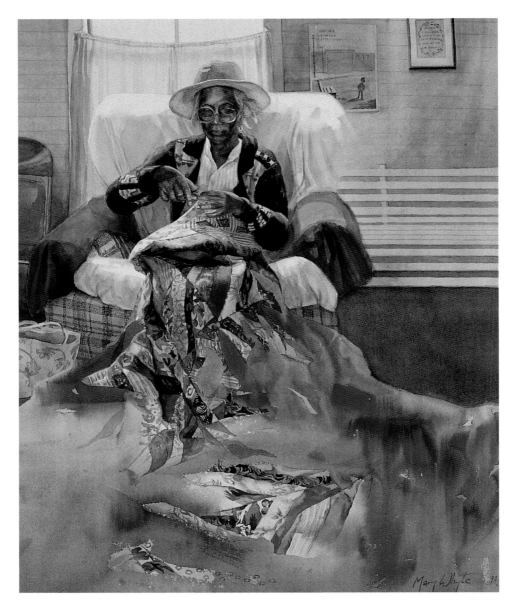

*Queen*

Mariah passed away on a warm Wednesday in March. She had missed the meeting the previous Wednesday but, up to the end, she had remained in fairly good health. I pictured her soul carried up to heaven on the wings of one of her songs. The funeral at her church was packed. Hundreds of people had come to pay their last respects to the matriarch of Johns Island. I arrived early, and still there were almost no places to sit. I slipped into the last pew, next to my neighbors Ann and Betty, the only other white people in the church.

The room was a cacophony of wailing and moaning and organ music. Everyone was swooning, rocking, crying, fanning and singing. Ladies in white uniforms with little gold medals on their lapels were furiously waving fans at the crying family members in the front row. There were dozens of white paper fans stamped with the name of the funeral home.

The organist started a new song, a low hum that turned into the synchronized humming of the congregation. Suddenly, an arm touched my elbow and urged me to stand.

"Follow me," whispered a young woman in the white uniform. I stood up, and she led me, as well as Ann and Betty, to the front pew along the side of the altar. We were so close to the casket I could have reached out and touched Mariah's forehead. The preacher, sitting in his chair facing the congregation, nodded at us. I leaned over to Ann.

"Why did they move us up here?" I whispered in her ear nervously.

"Well, things are different today," she murmured, "but in

Mariah's time, it was considered an honor to have a white person at your funeral. And the more honored you are, the closer you sit to the deceased."

Through the flowers around her casket, I could see Mariah's face was covered with powder. She was wearing her blue and white dress, and white lace gloves. The room was filled with the sounds of clapping and stamping feet. Even the men were crying and moaning. The crowd started swaying and singing, and then the fans burst into furious batting in the front corner as one more person fainted. I recalled once hearing that if you were touched by Mariah you had been touched by the hand of God. I gently brushed my hand over my arm, remembering where Mariah had once touched me.

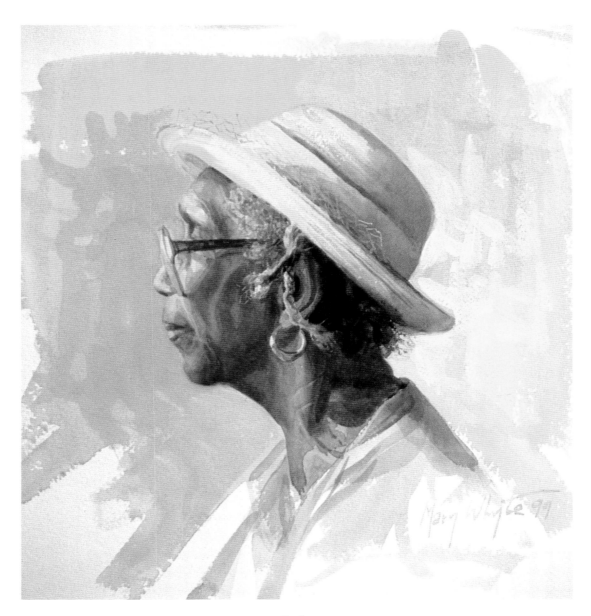

*Praise*

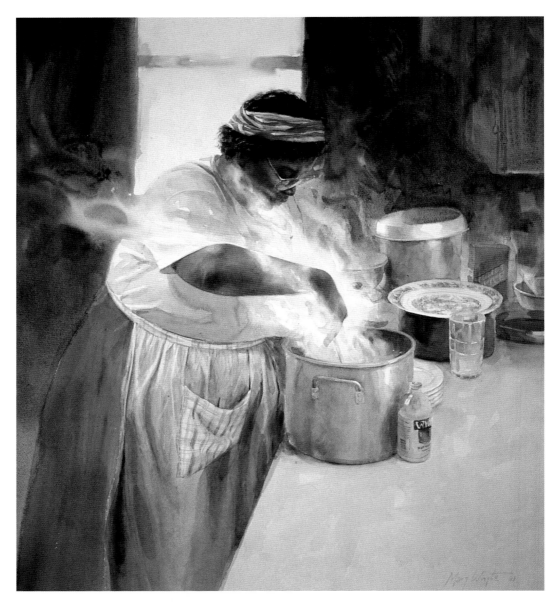

*Sunday Dinner*

Alfreda invited me to her family reunion, which took place under a giant white tent in her backyard. I was the only white person among the two hundred at the party. Alfreda introduced me to each of her cousins and uncles and grandnieces, leading me by the arm through the crowd. We joked about who in her family had "jumped the fence" to bring me to the party. Babies were thrust into my arms, as well as drinks and plates of food.

"Cousin Emma," she'd say, "I'd like you to meet Mary Whyte. She's my vanilla sister."

My heart flooded with warmth. On the surface, and when I first met her, I'd felt that no two people could be more different than Alfreda and I. But I was beginning to see that we were both artists who yearned to draw the same images of life. It's not that we were becoming more alike. But we were discovering—together and for the first time—how similar we have always been.

"Gads, Freda," I said, looking around. "Are these really all relatives? My family could have a reunion in a phone booth."

She laughed.

"Well, now, they don't all come from here," she explained. "Some from New York and Tennessee. Some from upcountry. Most from around here though. That's why they say you never marry someone from Wadmalaw Island, 'cuz they might be your cousin."

We walked to her back door and stepped into the kitchen. A half dozen young women in their twenties and thirties were shuttling pans of macaroni and cheese between the oven and

the counter, and tending to two large steaming pots on the stove. Alfreda introduced me to the women, each of whom gave me a hurried hug before returning to the food. I followed Alfreda into her dining room, where the table and even the chairs were laden with food. There was a huge sheet cake in the center of the table, frosted in red, white and blue with block letters in the center: "LaBoard Family Reunion."

I squeezed into an empty chair near the wall. Reaching into my handbag, I handed Alfreda a small gift in pink wrapping paper with a silver ribbon.

"I brought this for the reunion," I said.

Alfreda unwrapped it carefully, smoothing and folding the paper. She held up a small silver frame for the other women to see.

"It's for a photograph so you can remember today," I explained.

"Oh, child, I always remember today," she grinned. "And if I forget, God remember it for me."

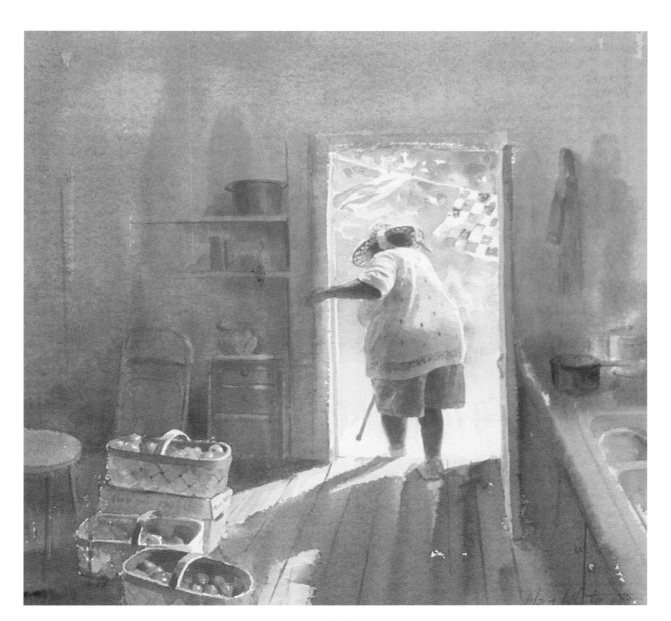

*Out the Door*

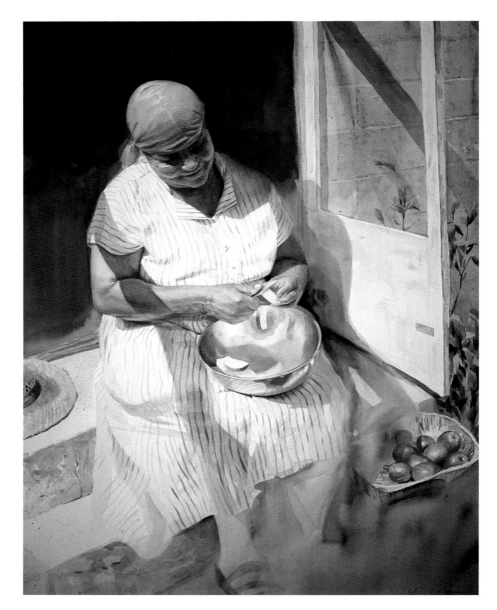

*Sliced Apples*

I planned a surprise party for Smitty's birthday and invited Alfreda, Isaac, Mary Simmons, Florence, Hortense and Rebecca. The ladies spent hours picking crabs, cleaning shrimp, chopping collard greens and cooking okra. My little kitchen pulsed with many cooks, our chatter rising and swirling with the steam from the boiling pots of collards and red rice. Crab cakes crackled in large cast-iron frying pans, and okra gumbo bubbled next to a tall platter of cornbread. Chicken, shrimp, sweet potatoes and pistachio bread pudding were ready for serving on the counter.

When he came home from work, Smitty was delighted to find a large group of his friends to toast his birthday. And a few of our friends were probably surprised to meet my Gullah friends there, too. The sun lowered over the marsh, easing the tidal stream into a red ribbon leading out from our deck. Most of the guests were outside, admiring the white egrets resting on old oaks, when a song drifted out from the house, calling them inside.

In the living room, Alfreda, Mary Simmons, Florence and Rebecca were standing in a row, humming in a deep baritone. Mary Simmons, leaning heavily on her cane, closed her eyes and tilted her head back. The melody of an old blessing filled the room with graceful but powerful harmony.

Dinner was served round and round. Piles of crabcakes kept reappearing from the kitchen, along with more servings of everything else until everyone begged for mercy. Smitty rubbed his stomach and tabulated with the others how many servings were eaten.

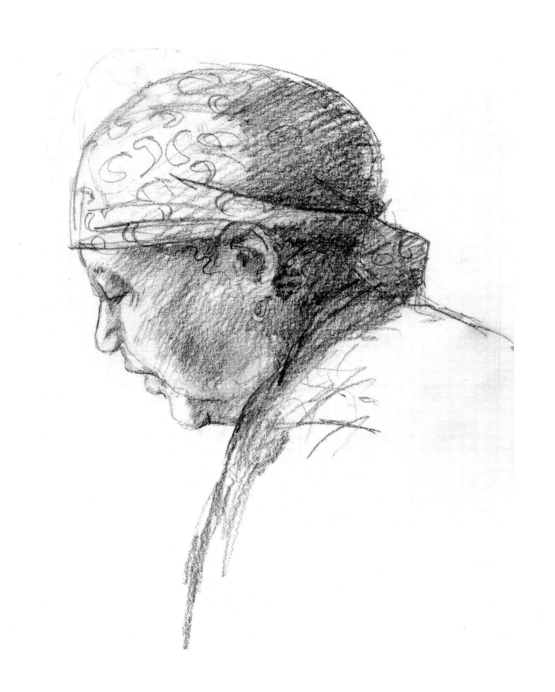

I pulled the women out of the kitchen still carrying wet dishtowels, as the guests applauded the meal. I gave Alfreda an encouraging nod as the women stood side by side and began to sing. The song that may have wobbled on the first few notes soon gained its footing. The voices, strengthening with ancestral echoes rising from deep within the belly of the island, swirled around us pulling us inward and upward. The other guests were simply mesmerized. I stood back and watched their faces. Some had tears in their eyes. I recognized the expression of weary travelers who are suddenly aware that they're standing on their own front steps. When the hymn ended, Alfreda took Smitty's arm and looked at him, smiling.

"Happy birthday to you," she sang to him, never removing her eyes from his. Alfreda's face glowed like the morning sun, and Smitty's face answered back, ever steady and sure, shining like the evening moon as she sang the simple tune. I don't know if anyone else ever gets to experience a moment like that one, watching two people you love most in the world in a simple human exchange that embodies the divine. If I could live one event over again, of all my life, it would be that one. How long was the road that brought me here.

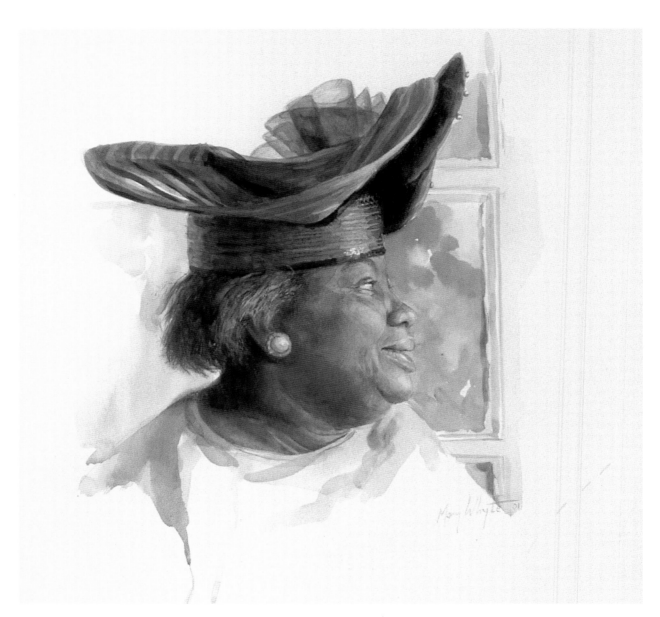

*Alfreda*

Alfreda's trips to the hospital are more frequent now. I go visit her and stand by her bed, stroking her soft arm and feeding her orange sections. She is always groggy at first, because the pain medication is strong. She soon becomes more coherent, asking me about my work. I talk to her about paintings, especially the ones of her in her Sunday hats.

I ask about what her doctors say. They want to perform surgery on her back, because she spends most of her day motionless, unable to move her toes. Martha Stewart smiles down from the high-mounted television in the corner.

"Freda, please hurry up and get better," I said one day. "Too many people depend on you. How can we have Thanksgiving at the Senior Center without you?"

She laughed softly.

"Oh, sweet Jesus, everybody depend on Freda for everything. The Harvest Tea is next Saturday and I supposed to do that too."

"There are plenty of ladies who can handle the Tea," I replied. "What's more important is fixing you. Getting you up and on your feet. Getting you home."

"Oh, child," she sighed, closing her eyes. "It's a time, I tell you. Sometimes the pain's so bad all I can do is call on my Jesus. And then I feel His hand on my shoulder and I feel a peace. And I know I be all right."

She slowly brought her hand to her shoulder, resting it on her blue and white hospital gown.

"Yes, I be all right," she whispered.

I leaned against the bed as she dozed off. Her face was

relaxed, her chin resting on her chest. I wanted to put my head down on her pillow and lie beside her, feeling the warmth of her body. I listened to her steady breath, and air passing through her lungs like the sound of the ocean breeze on marsh grass.

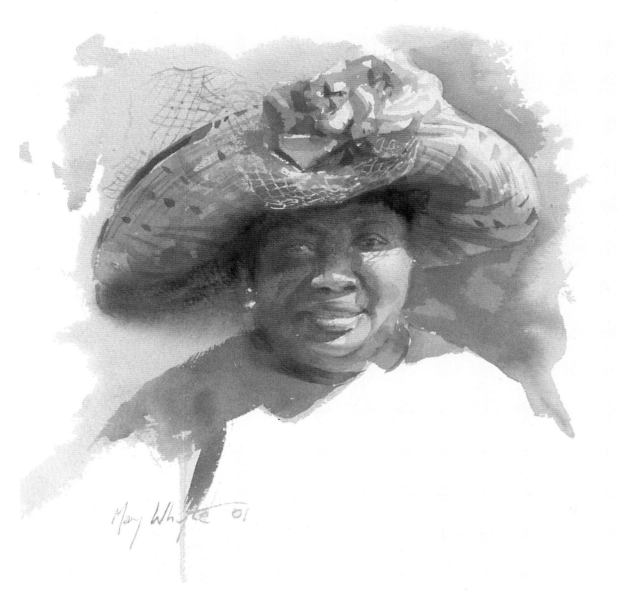

*Sunday Hat*

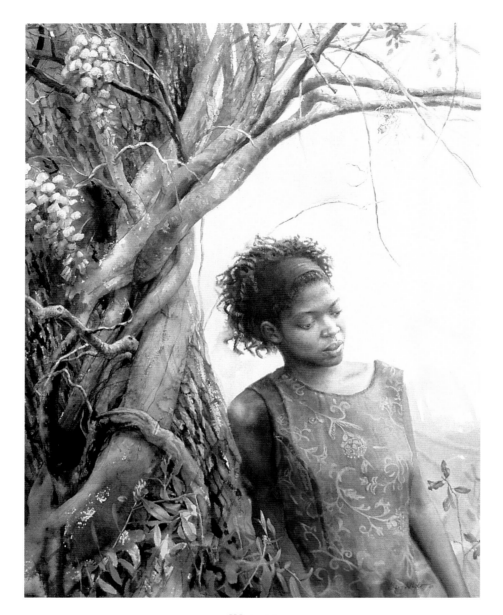

*Wisteria*

Hiiii," Alfreda's voice crooned into my receiver. Alfreda and I talk on the phone about once a week, in between Wednesday meetings. If I'm not at home, she leaves me a message telling me to have a blessed day. If I am home, we chat about business and family life. When I hear her voice now, I know it well enough to notice any worry, pain or exhaustion. Today, she sounded great.

"I just calling my Mary to say thank you," she said.

"For what?" I asked.

"I just calling to say thank you for bein' you. That's all. I thank my God for you bein' you."

"Well, thanks," I chuckled.

"Yes, ma'am," she continued, her voice growing louder. "I just called to say hi and to tell you about the conversation I had this morning with my grans." Alfreda's grandchildren live across the street from her, but spend most of their day at her house.

"Ty asked me—you remember Ty, my baby—she asked me 'Grandmama, who your best friend?' I had to think a minute about that one," Alfreda laughed.

"Them grans always asking me the big questions. So I answered her, 'Ty, you know, a best friend is someone who always know what you thinkin'. And a best friend is someone who always be doin' for you, and always know what you need before you ask. It's someone who always there for you, even when there's no soup in the pot.'"

I listened silently.

"So," she continued, "I said to Ty that my best friend was

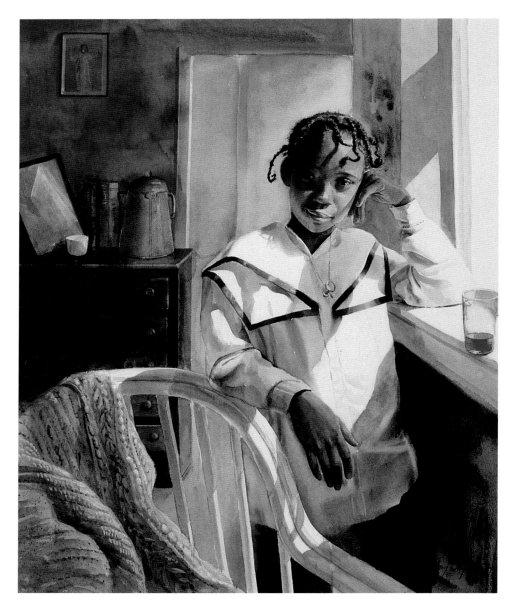

*Sunday*

Rosetta, who I've known since I was two. You know Rosetta. She live down the road."

I remembered Rosetta, a tall wisp of a woman with a lot of energy and spark.

"But then I got to think," Alfreda continued on the phone. "and I said to Ty, 'Well, now, I guess my other best friend would have to be Mary.' And I say to all the grans, 'You remember Miss Mary,' and they say they do. I tell them that you my other best friend, and that I want them never to forget that. I tell them it's important they never forget that."

I pictured her grandchildren standing around her, nodding obediently.

"Then I ask my gran, 'Ty, who *your* best friend?' and she say to me, 'I don't know, Grandmama, but I workin' on it.'"

Tears came to my eyes.

"So," Alfreda said, "I just wanted you to know that. And you remember I told you that, too."

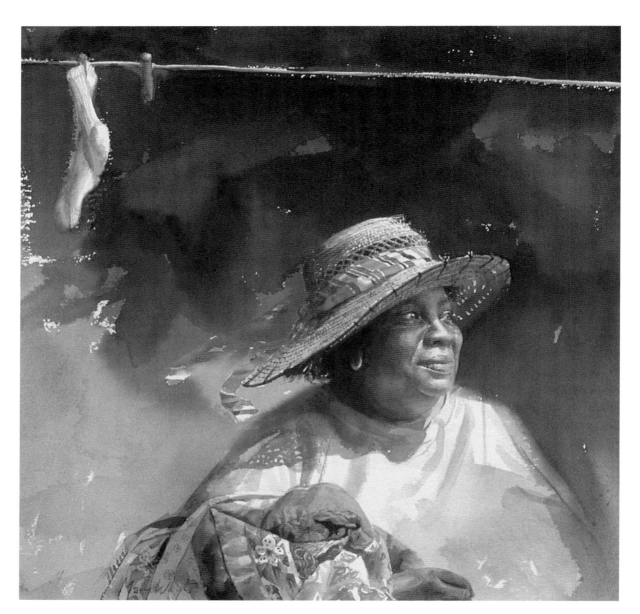

*Alfreda's World*

Spring arrived on a royal red carpet of azaleas. The trees limbs were heavy from yellow pollen in the Spanish moss and the bursting buds on thick wisteria vines. I was consumed with work for an upcoming gallery exhibit, under deadline for five new works in only ten days. Driving past Alfreda's house, I noticed her outside working in the garden. I was in a terrific hurry, but something drew my car to the side of the road and I got out to say hello.

Alfreda was planting okra and butter beans while her one-year-old twin grandchildren played in the gravel driveway.

"This garden take a lot outta me," she said as she leaned over to yank a weed from the furrow. Alfreda's pain is buried deep in her back and hips. Her cane was leaning against a tree.

"And I gotta put up those peaches, so I can put them out on the road stand and pay my water bill," she continued. She stood up, looked at me in my paint-spattered jeans, and smiled wearily.

"Well, lookee you," she said. Her joy can be frightening, when it rolls in on the heels of fear. But it is empowering. This was the reason I pulled the car over here, in spite of the million things I needed to do at home. Alfreda teaches me fearlessness on a daily basis. I can see God's work in the colors of azaleas and pachysandra, but I feel His presence in Alfreda's garden of mud and seeds. Our gardens sustain us, as well as helping us to sustain one another.

I look at the way the sun touches Alfreda's perspiring face, turning it gold. I look, too, for the other unique signposts of her face I used to notice: the coffee-colored skin, wide nose,

full lips, and I realize I can no longer see them. Now, if someone asked me to describe Alfreda in one pencil line, I no longer can. She has become too familiar, yet no longer physical at all. The many facets I know are innumerable. Too many mirrors of God.

"Mind if I walk down and paint the river?" I asked, gesturing in the direction beyond her turquoise cinderblock house.

"Help yourself," she replied, bending down to continue her planting. "And when you finished, come on back and we'll have us a nice glass of ice tea."

I gathered my easel and paints from the car, and headed for the river on foot. It is a silver, shimmering thread in the distance. Looking back over my shoulder, I could see Alfreda's stooped figure moving slowly up the rows of her garden. The same sun that touched Alfreda's back touched mine, and I closed my eyes, imagining God's great hand gently guiding us. Like walking through my house in the dark of night, I cannot see the walls, but I know they are there and I am comforted by them as I pass through the rooms, unseen.

# List of Illustrations

Page 50
*Dayclean,* 1998
Watercolor, 14 x 16 inches
Mr. and Mrs. T. Thomas Cottingham

Page 53
*Angel,* 2001
Watercolor, 20 x 28 inches
Daniel and Denise Smith

Page 54
*Patch of Shade,* 1998
Watercolor, 19 x 22 inches
Mr. and Mrs. Benedict Marino

Page 58
*Goin' Home,* 1993
Watercolor, 20 x 26 inches
Mr. and Mrs. Robert T. Applegate

Page 61
*Road Stand,* 2000
Watercolor, 23 x 20 inches
Mr. and Mrs. John Barter

Page 62
*Morning Star,* 2001
Watercolor, 21 x 21 inches
Harriet McMaster

Page 64
*Praise House,* 2001
Watercolor, 12 x 14 inches
Mr. and Mrs. John L. Paul

Page 66
*Queen,* 1992
Watercolor, 26 x 20 inches
Private Collection

Page 69
*Praise,* 1999
Watercolor, 12 x 12 inches
Mr. and Mrs. John Barter

Page 70
*Sunday Dinner,* 2001
Watercolor, 22 x 19 inches
Mr. and Mrs. Joe E. Taylor, Jr.

Page 73
*Out the Door,* 2002
Watercolor, 12 x 12 inches
Ms. Karen A. Kadlec

Page 74
*Sliced Apples,* 1999
Watercolor, 27 x 21 inches
Mr. and Mrs. Benedict Marino

Page 81
*Sunday Hat,* 2001
Watercolor, 10 x 10 inches
Mr. and Mrs. John Barter

Page 82
*Wisteria,* 2002
Watercolor, 40 x 28 inches
Mr. and Mrs. John Barter

Page 84
*Sunday,* 1994
Watercolor, 34 x 30 inches
Dr. and Mrs. William E. Cross, Jr.

Page 86
*Alfreda's World,* 2002
Watercolor, 20 x 23 inches
Rick Throckmorton and Edith Howle

Back Jacket
*Botany Bay,* 1996
Watercolor, 21 x 28 inches
Dr. and Mrs. Kipp Lassetter

*Drawings on pages i, 11,15, 24, 40,
57, 68, 76, 80 are in the
Collection of the Artist.*